PARADISE ROAD

Brian Sweeney
PARADISE ROAD

Essay by
Stuart McKenzie

CHARTA

Design
Anna Brown

Design Coordination
Mario Piazza, Letizia Abbate (46xy studio)

Editorial Coordination
Filomena Moscatelli

Copyediting
Emily Ligniti

Copywriting and Press Office
Silvia Palombi

US Editorial Director
Francesca Sorace

Promotion and Web
Monica D'Emidio

Distribution
Antonia De Besi

Administration
Grazia De Giosa

Warehouse and Outlet
Roberto Curiale

Cover
Taupo, New Zealand

© 2010
Edizioni Charta, Milano
© Brian Sweeney for his photographs
© Stuart McKenzie for his text

All rights reserved
ISBN 978-88-8158-761-2
Printed in Italy

Edizioni Charta srl
Milano
via della Moscova, 27 - 20121
Tel. +39-026598098/026598200
Fax +39-026598577
e-mail: charta@chartaartbooks.it

Charta Books Ltd.
New York City
Tribeca Office
Tel. +1-313-406-8468
e-mail: international@chartaartbooks.it
www.chartaartbooks.it

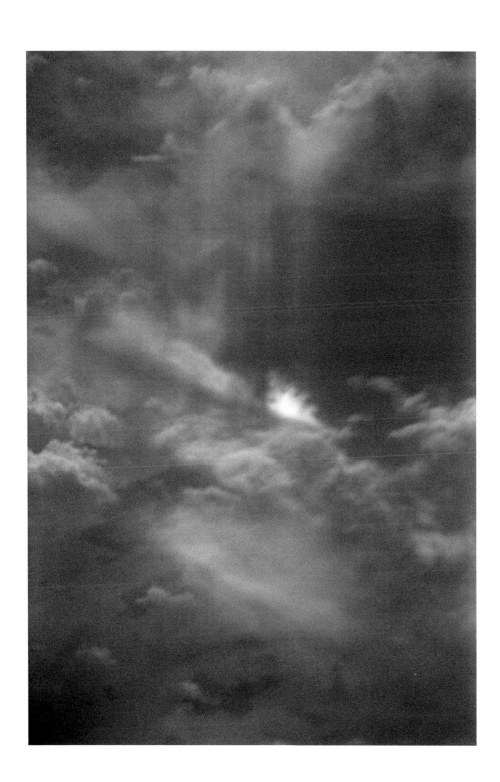

8

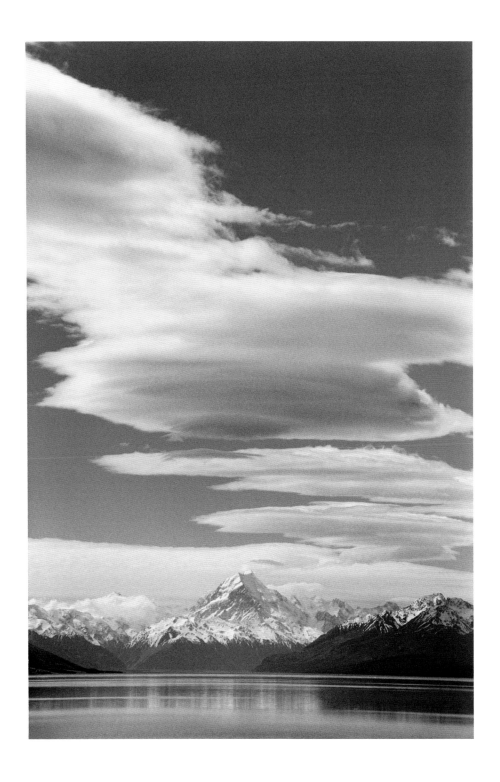

10

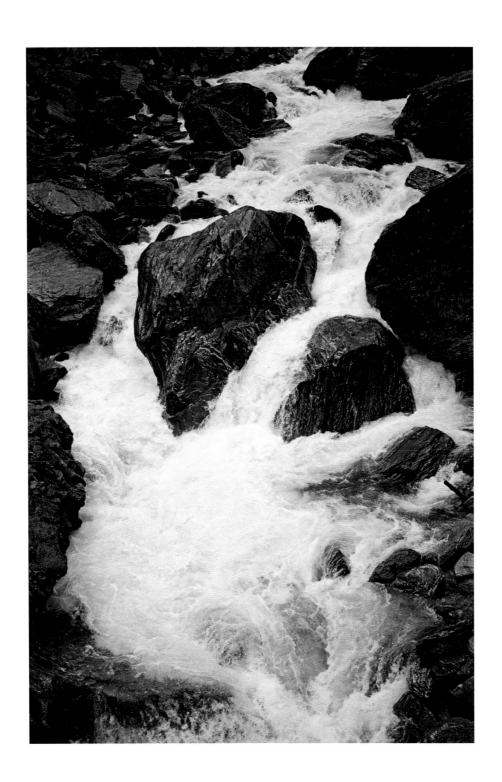

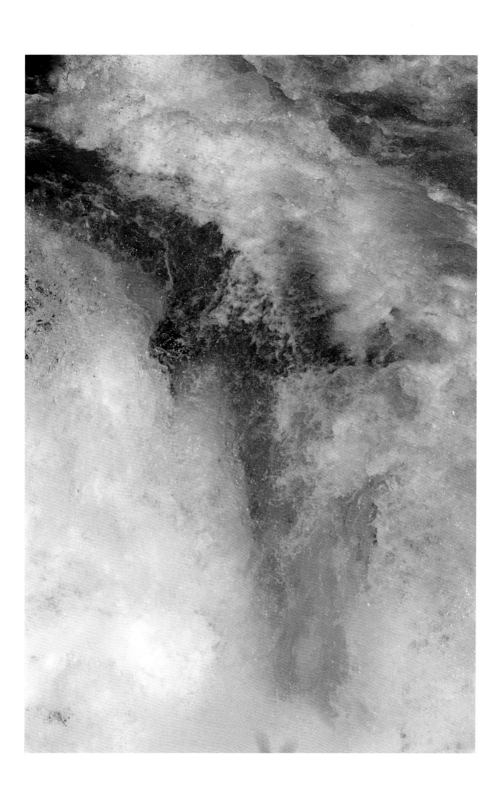

12

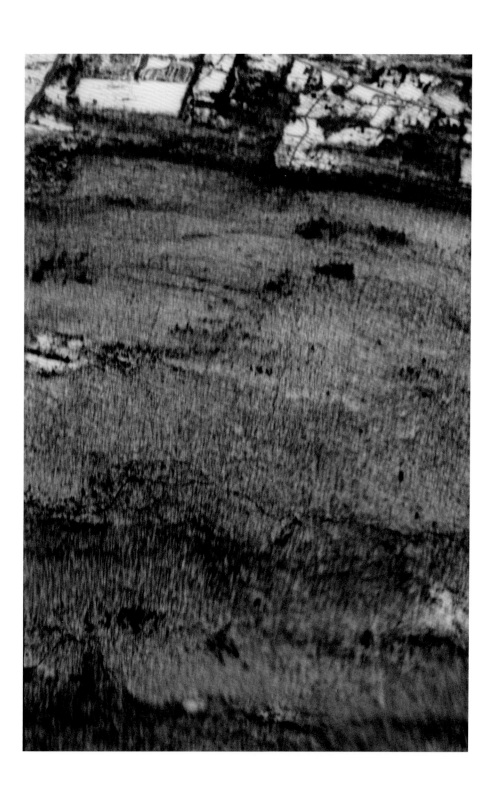

14

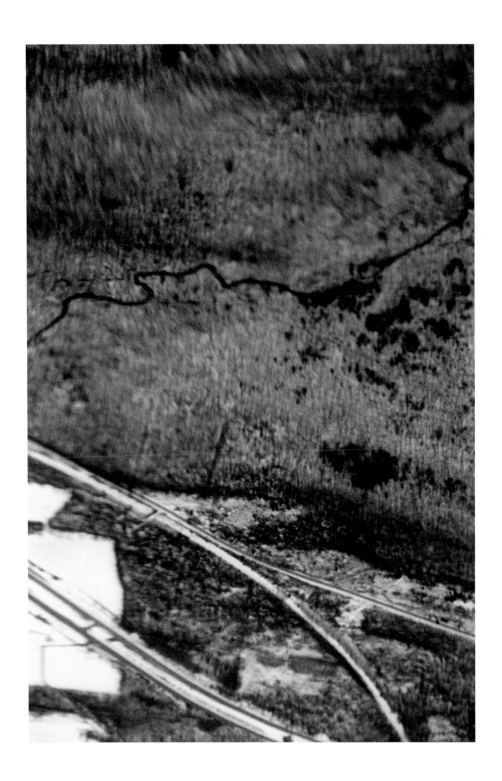

16

18

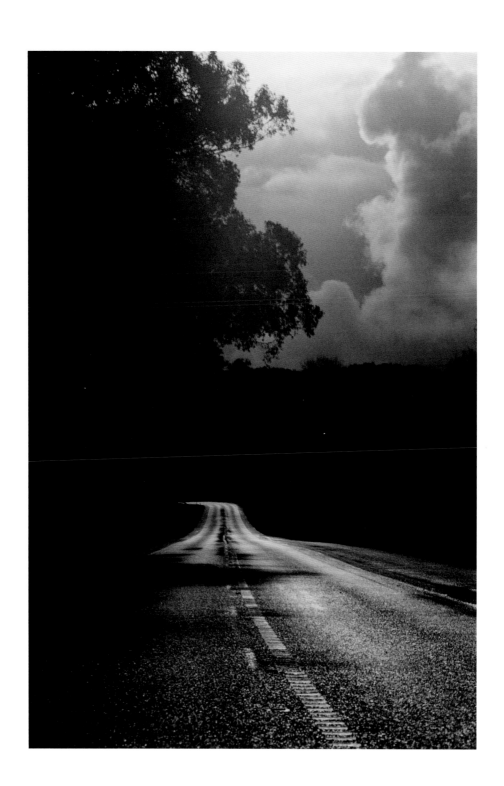

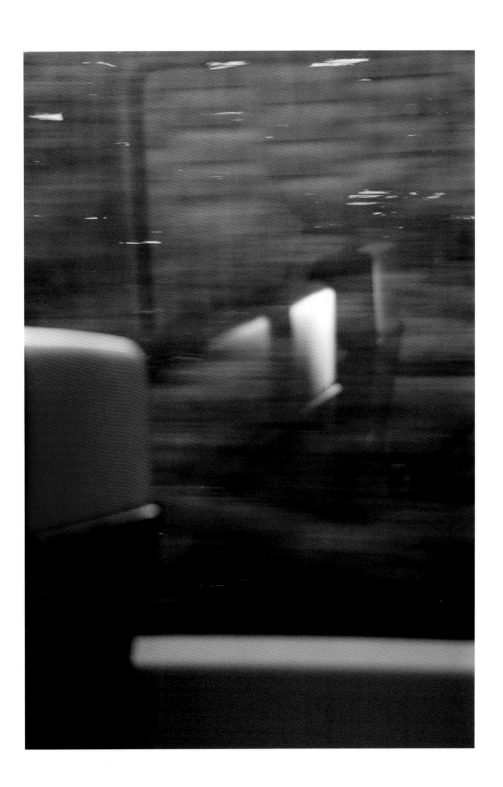

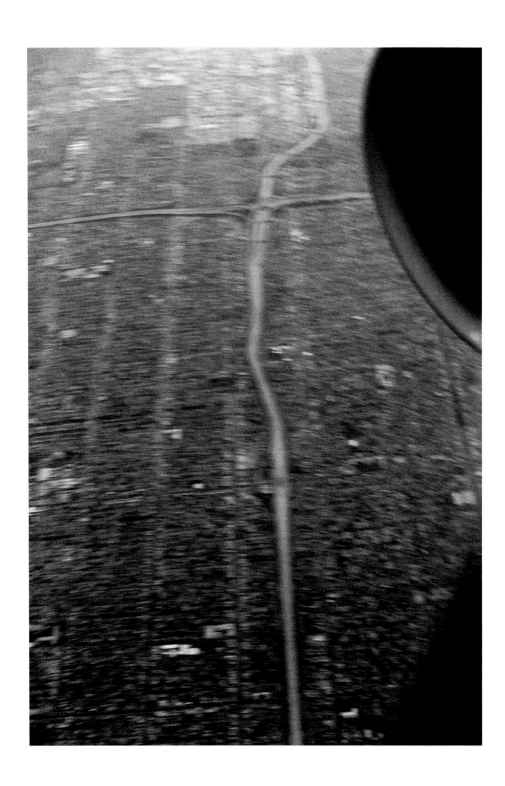

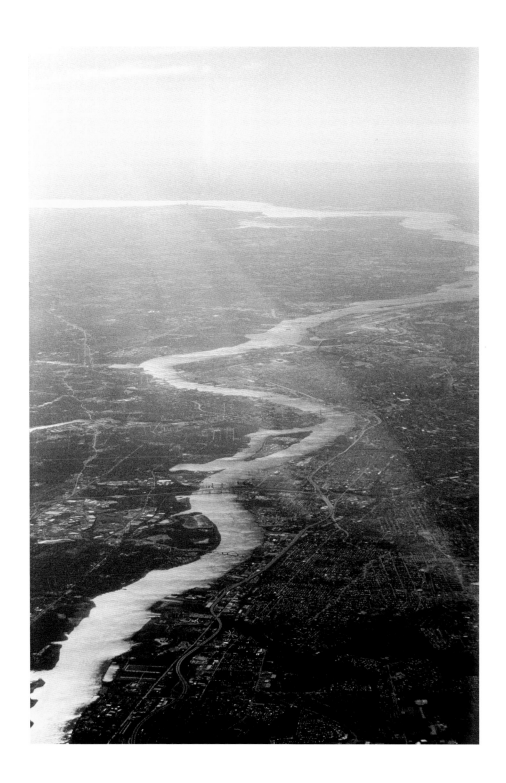

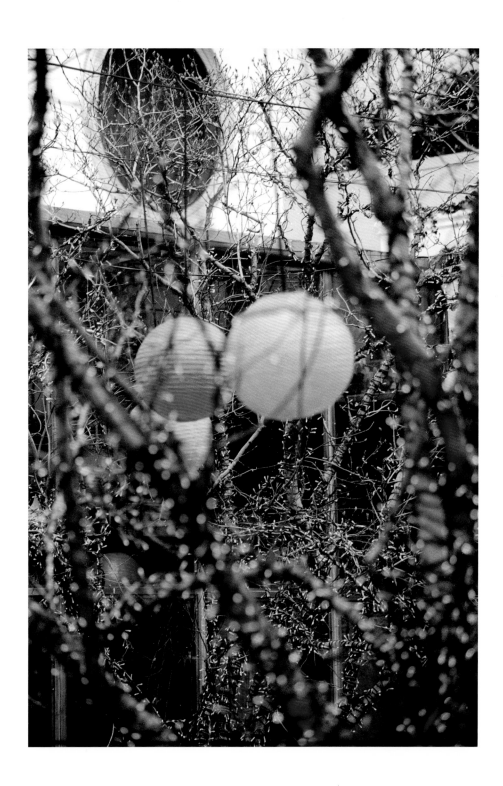

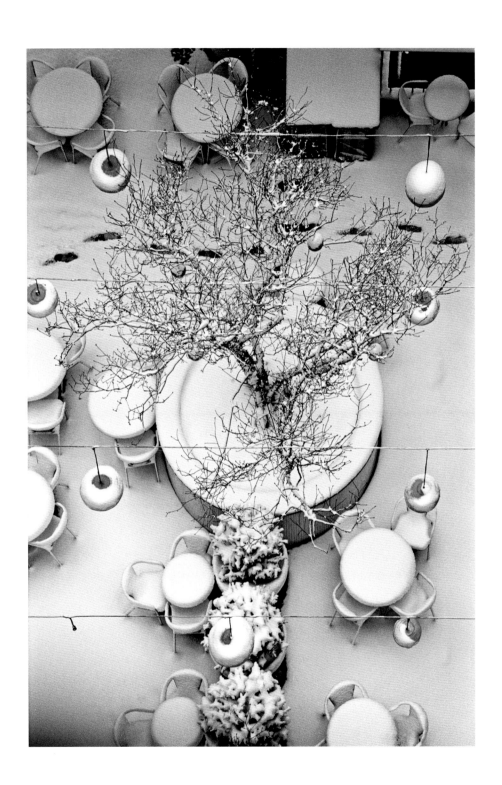

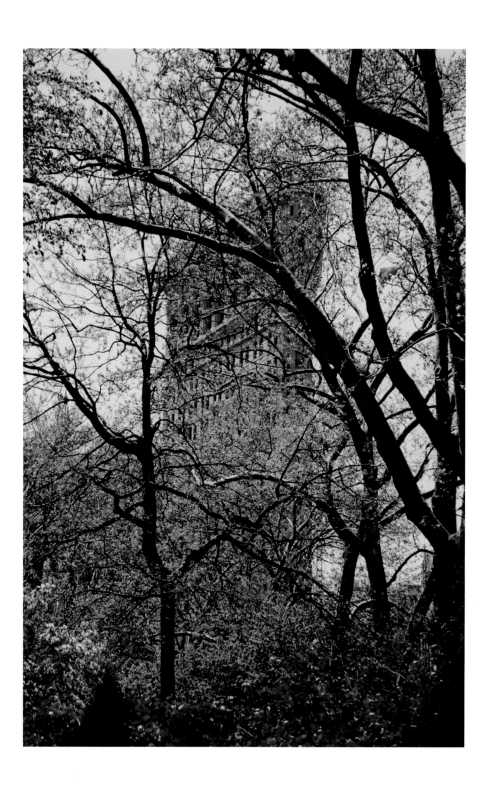

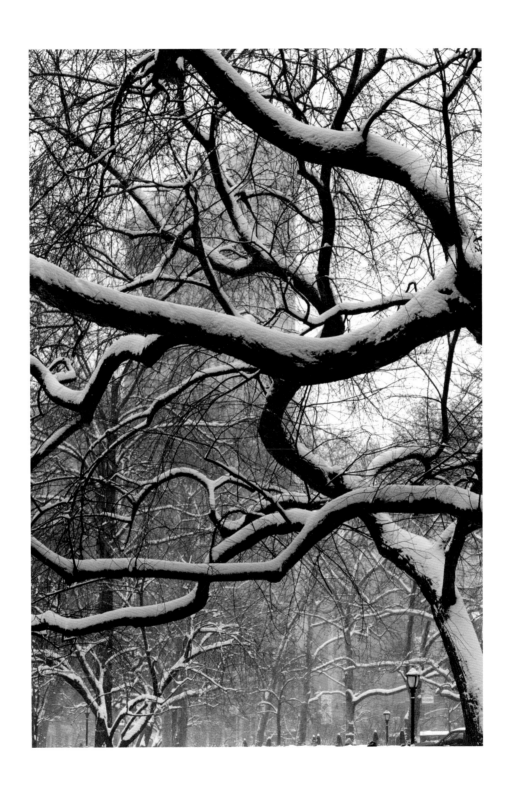

28

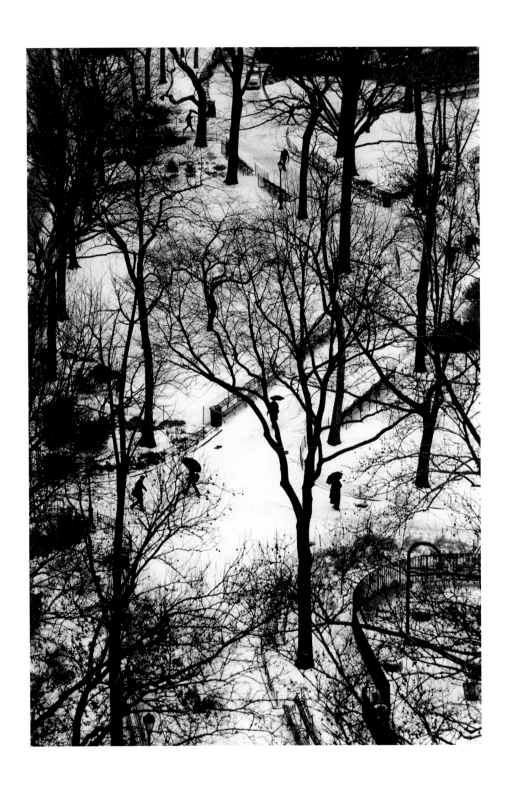

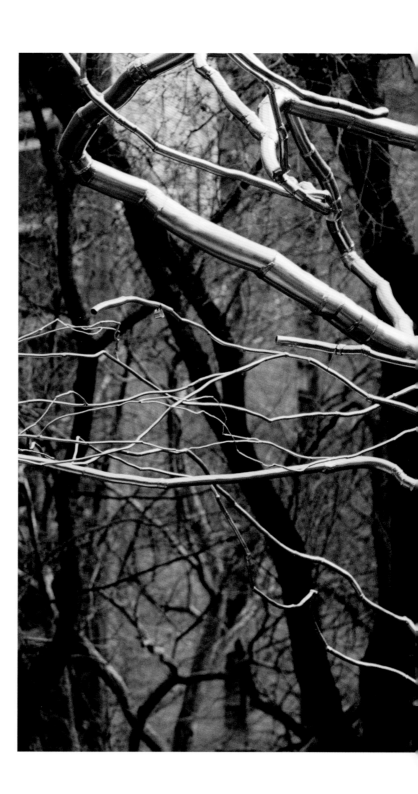

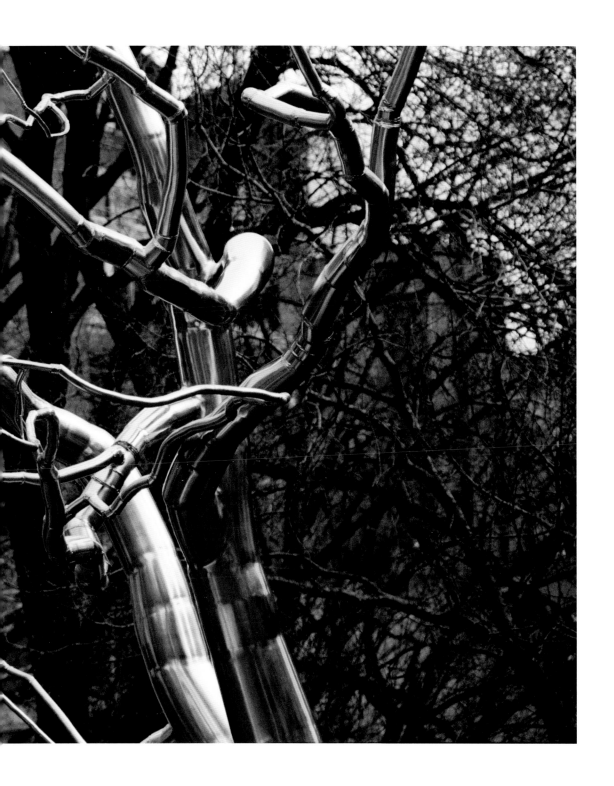

32

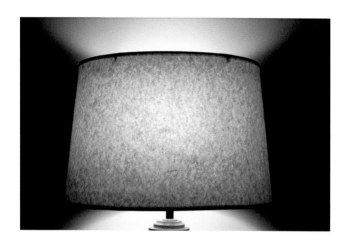

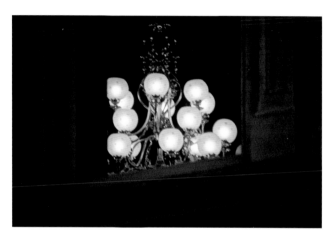

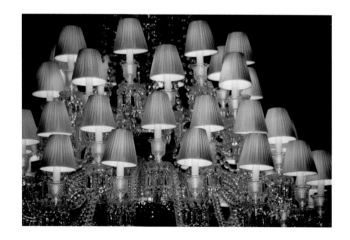

34

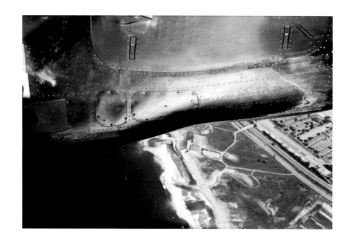

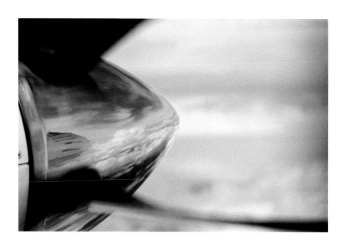

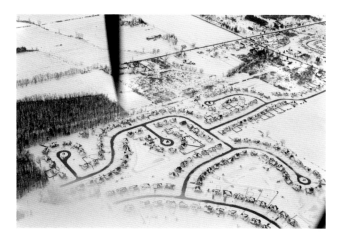

36

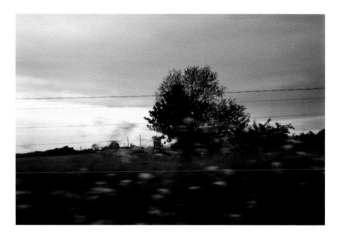

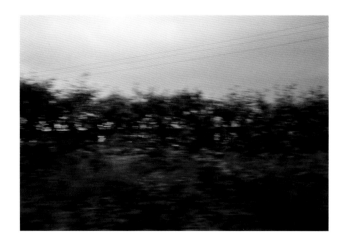

38

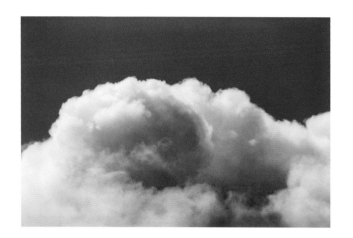

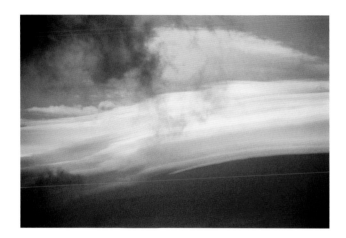

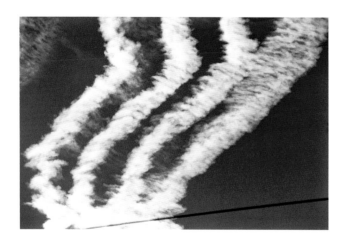

40

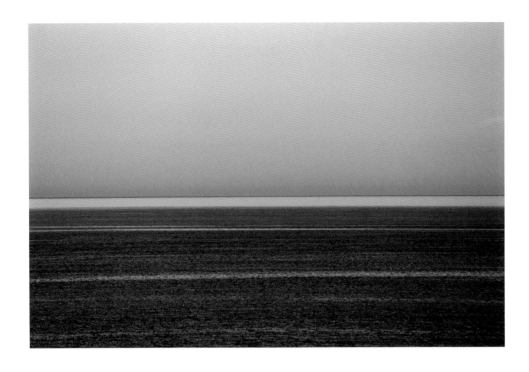

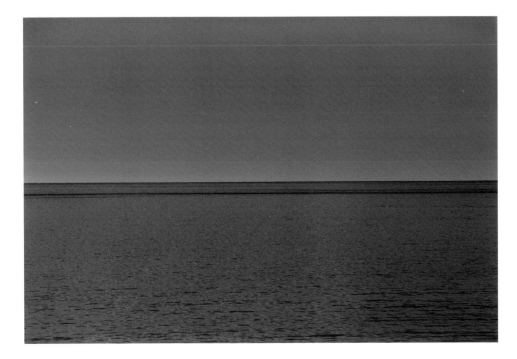

42

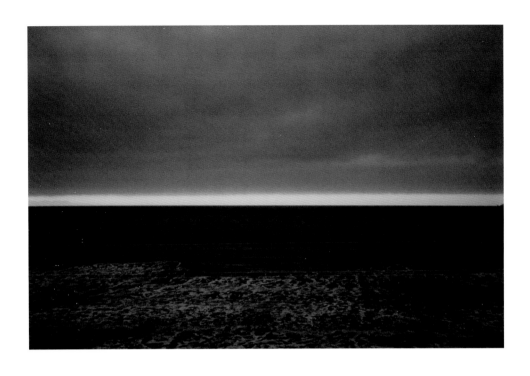

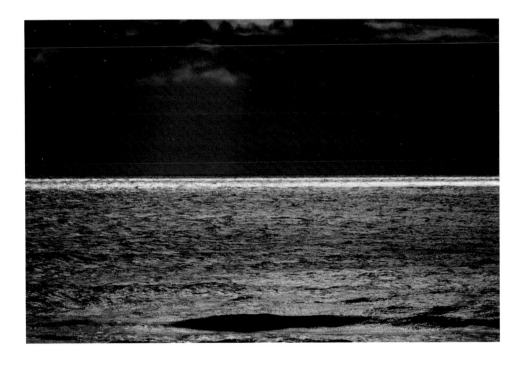

44

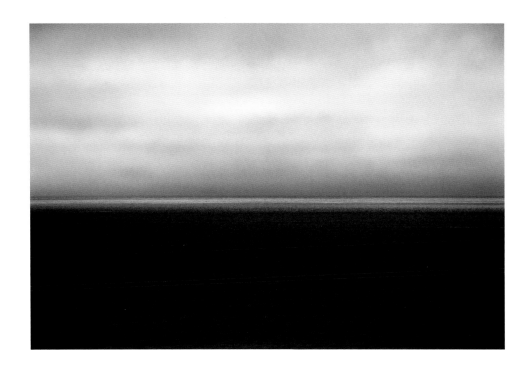

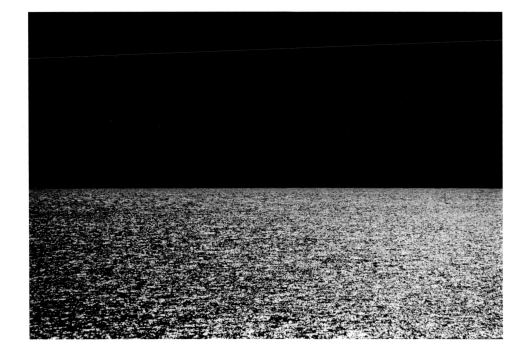

46

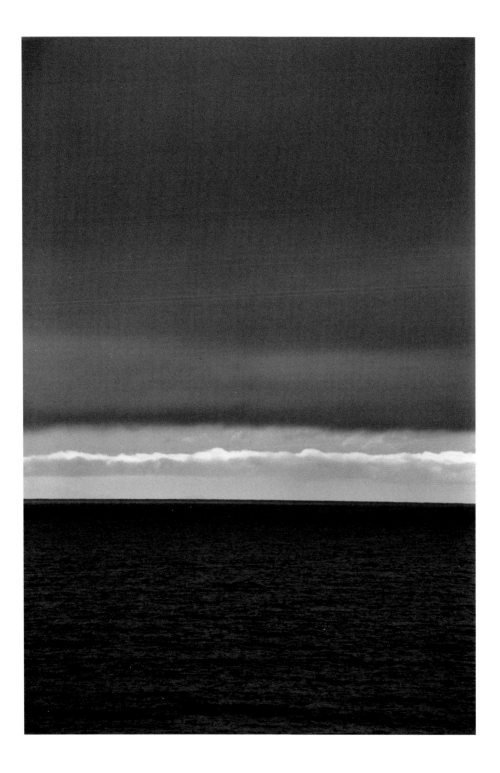

48

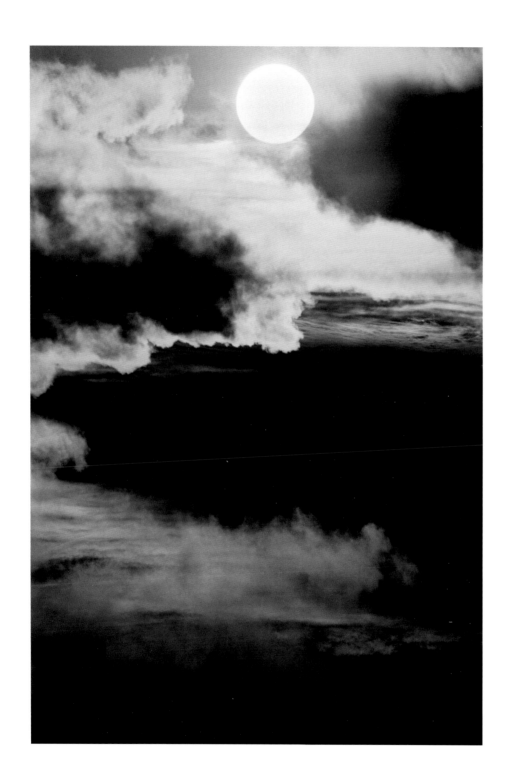

50

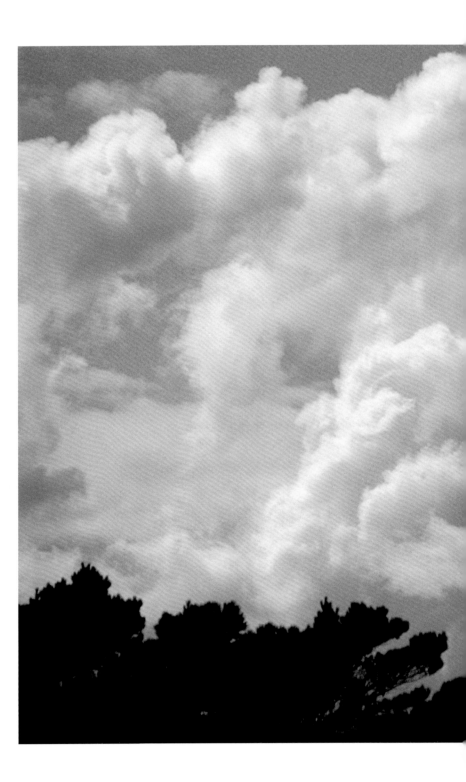

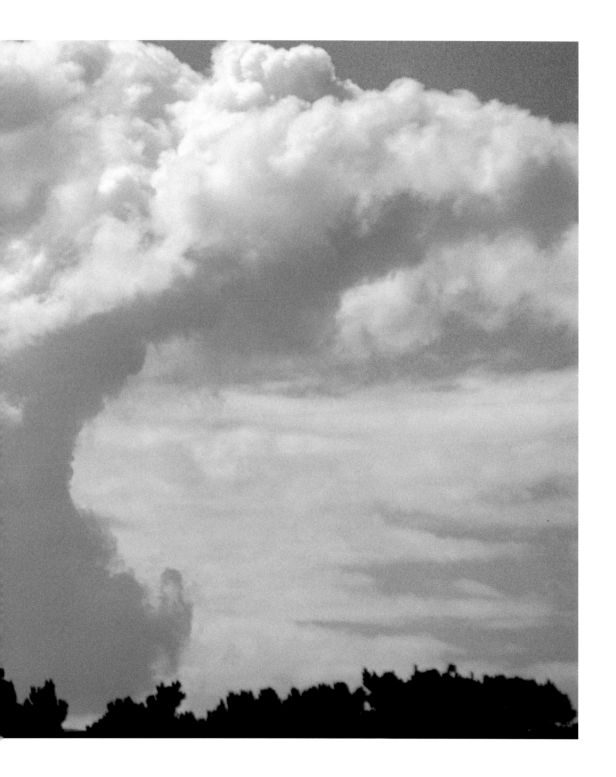

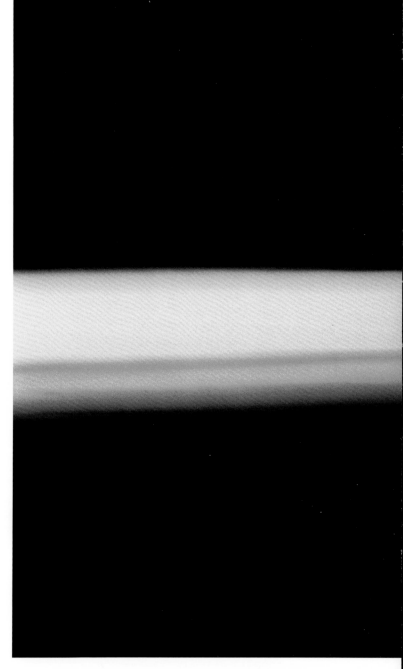

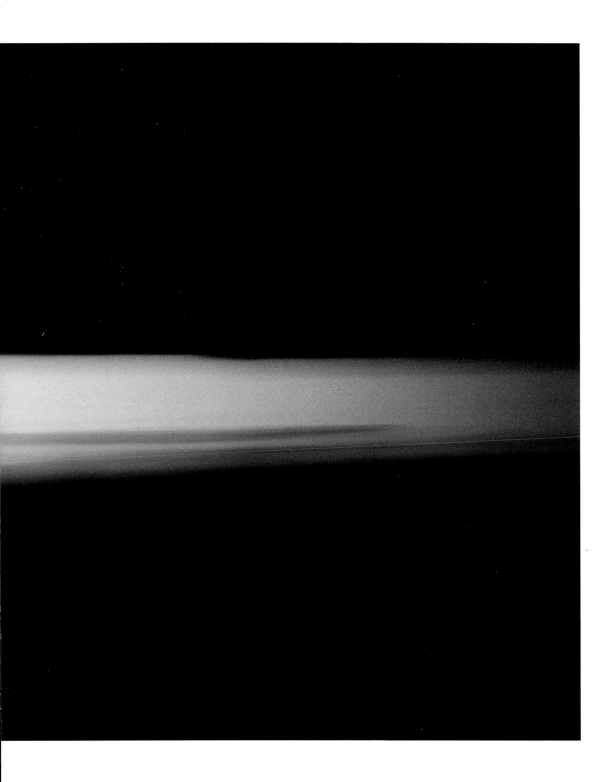

List of Works

Roxy Paine, Conjoined, *2007,*
Stainless steel, approx. 40 x 45 feet,
Installed at Madison Square Park, NY, NY
Artwork is © Roxy Paine/courtesy
of James Cohan Gallery, New York

PARADISE ROAD

Stuart McKenzie

For the invisible things of him from the creation
of the world are clearly seen, being understood by the things
that are made, even his eternal power and Godhead . . .
St. Paul, *Romans 1:20*

Out of the foaming ferment of finitude
Spirit rises up fragrantly.
Hegel, *Lectures on the Philosophy of Religion*

It is at the same time true that the world
is what we see and that, nonetheless, we must learn
to see it—first in the sense that we must match this vision
with knowledge, take possession of it, say what
we and what seeing are, act therefore as if we knew nothing
about it, as if here we still had everything to learn.
Merleau-Ponty, *The Visible and the Invisible*

W hen I first started emailing Brian Sweeney about his selection of photos for this book he quoted Ralph Waldo Emerson—"the sky is the daily bread of the eye."

The idea that nature is at once commonplace reality and uncommon sustenance—as in The Lord's Prayer, "give us this day our daily bread"—is at the heart of Sweeney's vision.

He mentioned he found the quote on a website dedicated to the Concord Transcendentalists. I should have, but from here in New Zealand I didn't realize that Emerson and Thoreau and their group were based around the little town of Concord in Massachusetts, New England. I assumed that Concord referred to a jet. And that the Concord Transcendentalists must be a modern movement finding inspiration in nature while on the fly! Of course, I realized my mistake when I checked out the website. But for Sweeney at least I reckon Concord Transcendentalist in my misguided sense fits perfectly.

So many of Sweeney's photographs are meditations on flight. From the air he sees the ground transpire beneath him. From the ground he lift his eyes into the light. Even when he is not physically on the move, his imagination takes off over earth and sea, beyond horizons.

Sweeney's business sees him fly regularly between New Zealand and New York. Over the years he has tracked his

movement between these two poles on a modest Canon with everyday Kodak film and a medium-sized zoom. His photos, whether taken at pace or rest, are invariably soaring—and picture nature full of meaning, even as it surpasses understanding.

Sweeney makes no attempt to trick out what he sees with high-end gear or intricate after-effects. His equipment is middle-of-the-road, but his eye is passionate and his vision of the world, religious.

Historian of Religions Mircea Eliade, in his classic 1957 book *The Sacred and the Profane*, contrasts the attitude and experience of religious man to that of non-religious man. For religious man, nature is never only natural; it is shot through with a sense of the sacred. But for non-religious man—a comparatively recent mode of being—the cosmos has been desacralized and is only ever what it is and nothing more. For the non-religious man, nature may of course be pleasing and in its way uplifting, but not in a way that connects him to a higher power.

(Let us say from the get-go that these two modes of being are often—and most often superficially—contrasted in the person of the artist on the one hand, who reputedly looks up, and on the other the businessman, characterized as obdurately down to earth. So, for Sweeney, artist and businessman at once, the idea of the sacred and the profane is already going to be contested and complex.)

Eliade uses the term *hierophany* to describe the manifestation of the sacred in everyday life. In a *hierophany* the sacred is witnessed as something absolutely different from the profane. But crucially and paradoxically, it is only ever *through* the profane that the sacred manifests itself.

By manifesting the sacred, any object becomes *something else*, yet it continues to remain *itself*, for it continues to participate in its surrounding cosmic milieu. A *sacred* stone remains a *stone*; apparently (or, more precisely, from the profane point of view), nothing distinguishes it from all other stones. But for those to whom a stone reveals itself as sacred, its immediate reality is transmuted into supernatural reality.[1]

The photographs in Sweeney's *Paradise Road* envision the world around us in its grandeur and banality as a sacred milieu to the very extent that it is not. Sweeney's photos reveal that the place apart is no distance from the way well traveled. Of course, the word "paradise" tells us to look up. But then again the word "road" advises that we keep our feet on the ground. If paradise is a place apart, road is a way in common.

The nineteenth-century Transcendentalists made a cult of nature. Not only did nature in its grand and overpowering

aspect communicate the infinite—in the sense of the sublime which exercised the imaginations of eighteenth-century artists and thinkers taking their lead from Edmund Burke—but also in its quiet and intimate moments. It is not only the raging storm, the frenzied surf, the blizzard, or the precipice that awes man with infinity, but also the contemplation of undisturbed nature. In his essay "Nature," Emerson writes:

> I become a transparent eye-ball; I am nothing; I see all; the currents of the Universal Being circulate through me; I am part or particle of God . . . I am the lover of uncontained and immortal beauty. In the wilderness, I find something more dear and connate than in streets or villages. In the tranquil landscape, and especially in the distant line of the horizon, man beholds somewhat as beautiful as his own nature.[2]

Brian Sweeney might well agree with Emerson that "the happiest man is he who learns from nature the lesson of worship."

The proper focus of worship was on Emerson's mind when he was invited to address the Harvard Divinity School on Sunday, July 15, 1838. He complained that organized religion had failed to communicate man's own infinite nature through an engaged appreciation of the outdoors:

> In how many churches, by how many prophets, tell me, is man made sensible that he is an infinite Soul; that the earth and heavens are passing into his mind; that he is drinking forever the soul of God? Where now sounds the persuasion, that by its very melody imparadises my heart, and so affirms its own origin in heaven?[3]

According to Emerson, the Churches had lost their way. By seeking to separate the sacred from the profane—and hoard it instead around their own buildings, vestments, and rituals—they had in fact lost touch with the sacred and diminished human nature at the same time. His words caused a scandal—especially as he advocated that the real miracle was nature and repudiated the need to believe in the supernatural miracles of Jesus.

The evaporation of the sacred from modern consciousness might be seen as an effect of organized religion's attempt to hold it apart. Certainly, Western man now tends to occupy a stubbornly profane cosmos diminishing him against its brute immensity, rather than exalting him through common cause.

Of course, non-religious man, in so far as this is an active role, attempts his own [tragic] grandeur by refusing any appeal to transcendence, seeking instead to raise himself up by himself. As Eliade explains, non-religious man:

makes himself, and he only makes himself completely in proportion as he desacralizes himself and the world. The sacred is the prime obstacle to his freedom. He will become himself only when he is completely demysticized. He will not be truly free until he has killed the last god.[4]

Intriguingly, however, Eliade goes on to point out that, whether he likes it or not, non-religious man is a direct descendant of religious man. To the extent that non-religious man has sought to purify himself from the beliefs and observances of his ancestors, those very behaviors continue to structure his existence.

He forms himself by a series of denials and refusals, but he continues to be haunted by the realities that he has refused and denied. To acquire a world of his own he has desacralized the world in which his ancestors lived; but to do so he has been obliged to adopt the opposite of an earlier form of behavior, and that behavior is still emotionally present to him, in one form or another, ready to be reactualized in his deepest being.[5]

In other words, while we may have lost a religious outlook, there are certain modalities of nature that continue to move us on a symbolic and/or unconscious level.

No doubt this is part of the power of Brian Sweeney's photographs in *Paradise Road*. Even if we don't view them through the eyes of faith, his keenly discriminated images of sky, clouds, horizons, mountains, water, and trees will nevertheless strike us with an atavistic sense of the sacred power of nature.

The sky is a recurrent symbol in Sweeney's work. As Eliade explains:

Simple contemplation of the celestial vault already provokes a religious experience . . . Transcendence is revealed by simple awareness of infinite height. 'Most high' spontaneously becomes an attribute of divinity.[6]

Whether he is on the ground looking up at the sky, or in the sky looking out or down, Sweeney's heavens are invariably shot through with clouds. Clouds have a transitional quality, linking the sky with the earth, the high with the low, the sacred with the profane. (In this respect, they offer a perfect path for Sweeney's imagination, as he seeks to invest the everyday and sometimes overlooked world with higher value.)

Perhaps, too, clouds for Sweeney are particularly seeded with meaning, given that the Maori name for New Zealand is *Aotearoa*—literally, "the land of the long white cloud." Named by the legendary navigator Kupe, traveling across the vast

Pacific from his homeland Hawaiki, the band of clouds on the horizon were a portent of landfall and a new world.

Like the sky itself, clouds have a long history in religious belief. In various mystical traditions clouds express the unknowable nature of the divine (for example, *The Cloud of Unknowing, a* medieval work of Christian mysticism).

When clouds lift or clouds part, something hidden is revealed. This in itself has a religious drift to it. When the clouds part, we glimpse the light. Veiling God, too terrible for human eye, the cloud already symbolizes the presence of God.

Early in religious evolution, the cloud was a symbol of the Mesopotamian storm gods; and in Egypt of the creation deity. Later, as Jacqueline Taylor Basker outlines in her fascinating essay "The Cloud as Symbol: Destruction or Dialogue":

> The Ancient Hebrews adapted the image of the cloud for Yahweh. As an aniconic people, who could not use a tangible material image to represent their god, the cloud provided a convenient insubstantial object to use as a visible symbol. During the wanderings of the Jews in the desert, the cloud hovers over or in the 'tent of witness' and plays a symbolic role as a recurrent theophany (an appearance of the Divine) in Old Testament scripture to witness the presence of God.[7]

The Old Testament use of cloud symbolism continues in the New, now underlying the divine nature of Christ, as we see in the Transfiguration described in the Gospel of Matthew (17:5):

> While he was still speaking, a bright cloud enveloped them, and a voice from the cloud said, 'This is my Son, whom I love; with him I am well pleased. Listen to him!'

Sweeney's use of cloud imagery is rich and multivalent. His cloud formations can recall religious ideas about the eye of God or clouds of glory, while also evoking secular notions of castles in the sky—or, in opposite mood, mushroom clouds and nuclear destruction.

Equally as powerful as sky and cloud in Sweeney's symbolic world is water. In religious myth, water precedes creation. We sense this in Sweeney's spectacular series of horizon photos taken from Raumati where he sometimes lives on the lower West Coast of New Zealand's North Island. In these images, where water meets sky in changing light, it is as if the void takes shape—a creation myth enacted for his lens. For Sweeney, who grew up Roman Catholic, the first verses of Genesis would surely have inspired his vision:

> In the beginning God created the heaven and the earth. And the earth was without form, and void; and

darkness was upon the face of the deep. And the Spirit of God moved upon the face of the waters. And God said, 'Let there be light': and there was light. And God saw the light, that it was good: and God divided the light from the darkness.

Water symbolizes creative potential. The actual world of form and endeavor emerges out of water and ultimately dissolves back into it, purified and washed clean. As Eliade says, water is the "reservoir of all the possibilities of existence." Likewise, the horizon line opens us up to unlimited possibility, releasing us from life as it has taken shape around us and into the infinite beyond. "The health of the eye," wrote Emerson, "seems to demand a horizon. We are never tired, so long as we can see far enough."[8]

In conversation, Sweeney often talks about the restorative effect of horizons, and in particular how this view from Raumati used to excite his wonder about what might lie ahead for him—a virtuality that became actual when he left these islands surrounded by water to reimagine himself on the island of Manhattan.

For Sweeney the cultural and business opportunity of America is a promised land that called him forth. New York in particular is the symbolic and storied center of the world, especially compared to New Zealand geographically and by association culturally on the edge of the world. But

just as the sacred and the profane are necessarily coterminous for religious man, the center and the edge fold over each other for Sweeney. Hence, in his photography, he brings together nature—symbolized by the New Zealand landscape—and culture—symbolized by New York.

Traditionally, as we have seen, it is nature that is commonly invested with centrality or sacrality. Culture, on the other hand, is man-made, temporal, and by comparison regarded as peripheral. So, already in Sweeney's work there is a certain displacement if not inversion between the idea of New Zealand and New York. According to this reading New Zealand would be a natural paradise and central while New York, teeming and distracted, would be far flung and on the edge.

But the more we contemplate Sweeney's photographs, the more we find these bi-polar world views artfully turned upside-down—his framing of nature is determined by both the history of religion and of art (and in this way are mediated or unnatural); while his urban views, equally mediated by art history, are presented as natural pieces of infinity.

You can see this for example in his image *Aoraki Mt Cook*. It speaks of incomparable natural splendor. As Sweeney says in conversation, "If mountains were show business this would be Broadway." At the same time, we can't help but be aware of its "chocolate box" vista—a view a million other travelers have snapped in

passing as they seek to eff its ineffability. Whether conscious or unconscious, the historical religious significance of such a sight is overwhelming—the mountain surrounded by water and piercing the clouds is a universal paradisiacal image— and yet for this very reason, to our well-tutored eye, the image can also be read as a familiar effect of enculturation.

In Sweeney's images, then, the sacred and the profane are in studied tension. In fact, it is along the horizon line of these two modes of perception that his images send our spirit flying.

Again we experience something like this in his photo *Road*. This was taken on a road less traveled near Lake Taupo in the central North Island of New Zealand—for those in the know, site of a massive eruption in 180 CE, recorded to have turned the sky red over China and Rome. All memory of such a cataclysmic past is absent in this beatific image. Sweeney says that he instantly recognized the image he wanted. He had his own road to Damascus experience. He stopped the car and took this single shot: light diffused through foreground trees, nimbus backed up over intervening hills . . . The shine and dip of tarmac curving elegiacally from sight, entering darkness before any promise of ascent . . .

At the same time as we appreciate the hallowed features of this journey along what we also know is just a mundane stretch of road, we recognize its precedents in the documentary vision of American roads by photographers such as Edward Weston (*New Mexico Highway*, 1937), Dorothea Lange (*The Road West*, 1938), or Robert Frank (*US 285, New Mexico*, 1955). Not a lonely country road at all, Sweeney's road turns out to be well traveled. And so, once again, not simply a spontaneous epiphany in the landscape, but a complicity of nature and culture, a charge of insight along the horizon line of the purportedly sacred and the allegedly temporal.

Again, Sweeney's cloud photos, which on the face of it seem to be a series of spontaneous visual prayers, can simultaneously be viewed as meditations on the history of art and photography— the Renaissance Assumptions and Transfigurations; the iconic puffed clouds of Magritte; the 1960s and 1970s cloudscapes of Georgia O'Keeffe (like Sweeney, mesmerized by views from airplane windows). Or Edward Weston's photographs of towering and striated Mexican clouds from the mid-1920s; Alfred Steiglitz's aerial views in his *Equivalent* series of photos from the 1920s and 1930s; Ansell Adams, Minor White, Ralph Steiner . . . the cloud chasers followed by Sweeney goes on. And his other-worldly view of nature is revealed—and is revealing—as self-consciously worldly.

Whereas the Transcendentalists needed to escape from towns and cities to commune with nature, Sweeney continues to find in manufactured landscapes and urban environments many of the

classic symbols and attitudes of religious man—trees and lights, changing seasons, views from high, views looking up. For Sweeney, the city is second nature—and as such his images here, to the very extent that they are commonplace, have the same revelatory effect as his scenes along backcountry roads or distant flight-paths.

Sweeney sees the light in things that someone else might regard as obscure, banal, incidental, or incomplete. A simple lamp in a hotel room; a chandelier in City Hall, New York, glimpsed from the street outside; a Philippe Starck lightwork in Paris' Baccarat Museum of Crystal. These three photos of fragments from bigger pictures—scraps from various excursions, but linked in his consciousness by a comparable glow—all communicate the religious insight of God shedding light to the world. Three modest infinities ripped out of time.

Each impression or passing moment, each lived experience relived through art is a fecundity, a sheer paradise. For Sweeney, New York itself is a paradise, insofar as it allows him to enter into the spirit of photographers like Steiglitz, Steichen, or Kertesz who made the pilgrimage before him and like him made the city their home. Sweeney himself lives above Madison Square Park across from the Flatiron Building, and Edward Steichen's iconic 1904 photograph powerfully haunts his own perception of the landmark.

Just as we feel the presence and spirit of others in his photographs, Sweeney often invokes in us the corporeality of seeing itself: the blur of motion, the play of light or streak of moisture on a window, the hint of the means of travel that sweeps the eye through the world.

This at the same time as he playfully acknowledges both the similarities and the differences in his worldview from the nature lovers and Transcendentalists who have passed before him. So, in his triptych of images from Britain's Lake District, we don't see any tranquil, Wordsworthian view of rolling fields, glistening water, or stone fences.

Instead, we catch a blurry view from a moving car of straggly roadsides that could be anywhere, but which nevertheless communicate the singular and exhilarating sense of an eye on the move, transported by the scene as much as it is transported through the scene.

Likewise, the diptych of photos that look like abstract expressionist paintings, but are actually the runway at speed at La Guardia Airport, inspirit a sense of timelessness in the very blur of time passing. (For the traditional Transcendentalists, infinity is best approached on foot. But for Sweeney, a Concord Transcendentalist in my misguided sense, infinity can also be grasped at speed.)

For Sweeney, vision itself is a miracle given off by the rub of embodied eye and physical world. When I look at his photos,

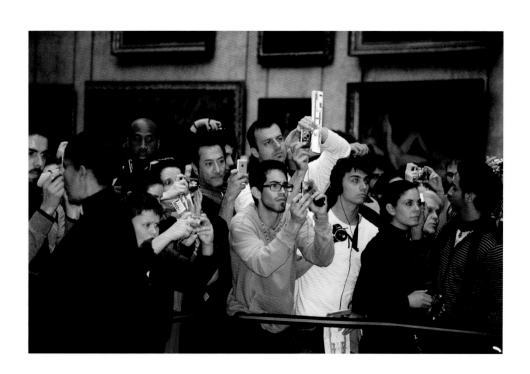

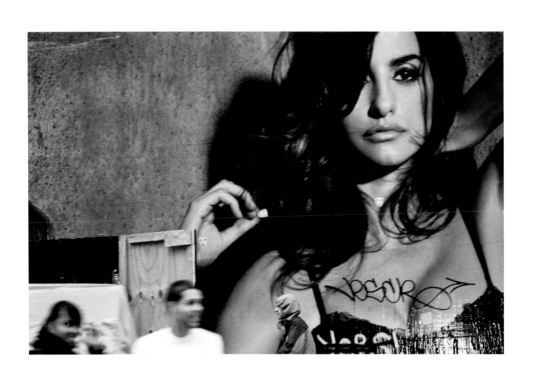

I am reminded of Merleau-Ponty reflecting on the act of seeing and perceiving:

> My movements and the movements of my eyes make the world vibrate . . . With each flutter of my eyelashes a curtain lowers and rises, though I do not think for an instant of imputing this eclipse to the things themselves; with each movement of my eyes that sweep the space before me the things suffer a brief torsion, which I also ascribe to myself; and when I walk in the street with my eyes fixed on the horizon of the houses, the whole of the setting near at hand quivers with each footfall on the asphalt, then settles down in its place.[9]

How we see, of course, both physically and culturally, determines what we see. (To make my point I take two photographs that aren't part of *Paradise Road*, but can be glimpsed along the verge.) We are culturally pre-determined to find revelatory experiences in certain places, like the photographers in Sweeney's photo of the crowd in the Louvre snapping at the Mona Lisa.

Perhaps this crowd in a hurry is a wry comment on Sweeney himself—although, as we have seen, he embraces speed to the point of stillness. But this frantic horde of photographers, desperate to catch their own fragment of the revelation La Gioconda represents, appear to miss entirely the elusive figure against her backdrop of nature.

Sweeney on the other hand, whose eye is quick to the edge as well as the center, finds revelation not only in the places that have been preordained, as in the quiet and timelessness of the landscape (although there as well), but also in the blur and contemporaneity of the city—as in a billboard of Penelope Cruz gazing Mona Lisa-like at us as the world goes wonderfully, blindly about its business.

1 Mircea Eliade,
The Sacred and the Profane: The Nature of Religion.
New York: Harcourt Inc., 1957, p. 12.
2 Ralph Waldo Emerson,
Nature; Addresses and Lectures,
www.emersoncentral.com/nature1.htm.
3 Ralph Waldo Emerson,
The Divinity School Address,
www.emersoncentral.com/divaddr.htm.
4 Mircea Eliade,
The Sacred and the Profane: The Nature of Religion,
Op. cit., p. 203.

5 Ibid., p. 204.
6 Ibid., p. 118.
7 Jacqueline Taylor Basker,
"The Cloud as Symbol: Destruction or Dialogue,"
Crosscurrents, spring 2006, p. 113.
8 Ralph Waldo Emerson,
Nature; Addresses and Lectures, Op. cit.
9 Maurice Merleau-Ponty,
The Visible and the Invisible,
translated by Alphonso Lingis.
Evanstown: Northwestern University Press,
1968, p. 6.

Biographies

BRIAN SWEENEY
was born in New Zealand in 1958.
He lives in New York City
and Raumati South, New Zealand.
He has a degree in Political Science
and works in business.

To see more work by Brian Sweeney,
go to *www.paradiseroad.com*

STUART MCKENZIE
is a playwright and filmmaker.
He has degrees in Creative Writing
and Contemporary Religion
and writes about the visual arts
in New Zealand and internationally.

To find out more about Charta,
and to learn about our most recent publications,
visit www.chartaartbooks.it

Printed in January 2010
by Tipografia Rumor, Vicenza
for Edizioni Charta.